INTRODUCTION

This book was designed to introduce the life and work of the artist Jacob Lawrence in an easy to read format.

Direct quotes from the artist appear in the yellow boxes:

> ## What Jacob Lawrence said.

Discussion about the artist's work appears in the white boxes. A red dot instructs the reader to go to the Activity Book to make a related art project:

> ### About his work
>
> Go to your Activity book for a related art project

The label gives you all the information about the painting. All of Jacob Lawrence's artwork is accompanied by an identification label, the same kind you will find in a museum:

The name or title of the painting
The year it was made
What materials were used to make it. Its size
Who owns it

In the **Activity Book** you will find easy to follow step by step directions to make art projects of your own.

Have Fun!

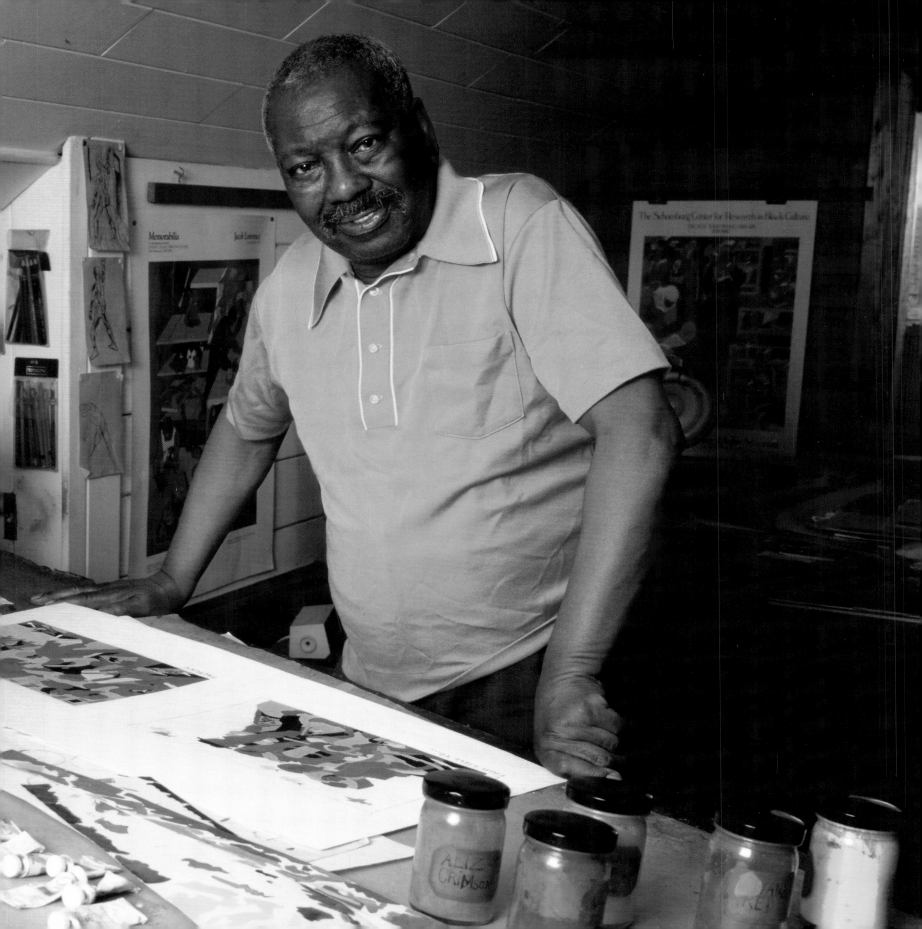

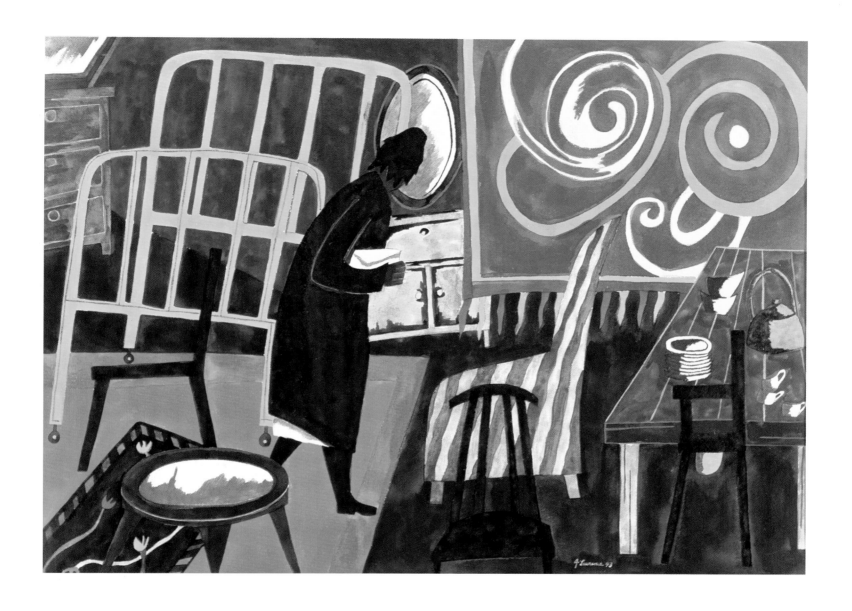

The Apartment 1943
Gouache on paper, 21¼ x 29¼"
Hunter Museum of American Art, Chattanooga, Tennessee,
Purchase with funds provided by the Benwood
Foundation and the 1982 Collectors' Group Funds

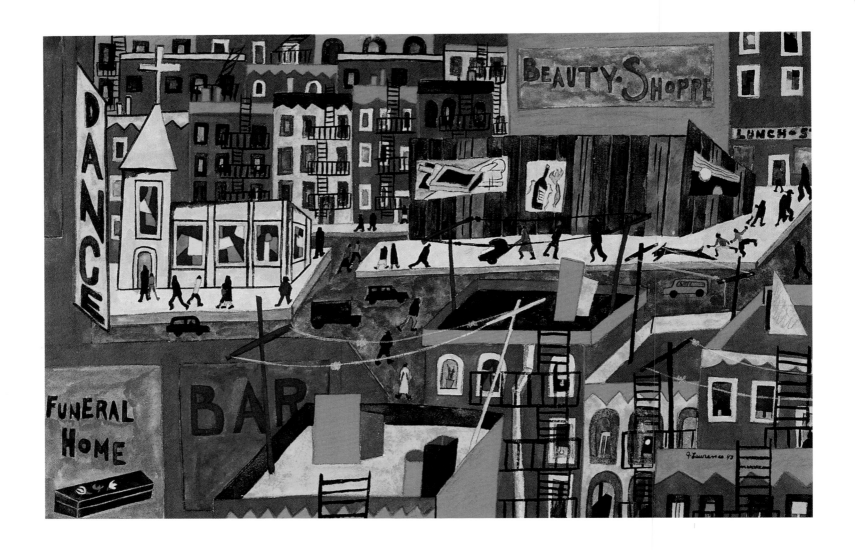

This is Harlem 1942–43

Gouache on paper, 15½ x 23"

Hirshhorn Museum and Sculpture Garden, Smithsonian
Institution. Gift of Joseph H. Hirshhorn, 1966

Jacob Lawrence was one of the first African-Americans to receive recognition as an important contributor to the history of modern art. Against difficult odds, Lawrence achieved his own original style of painting which combines storytelling in vivid colors and bold abstract patterns. Lawrence's work also addresses issues of African-American daily life, culture and history that had never before been explored by a visual artist.

> **"One of the fascinating things about art is that it has a magic."**

Jake was born in Atlantic City, New Jersey in 1917, but by the time he was six years old he had already lived in three different cities. His parents found it difficult to find jobs that were open to African-Americans. In 1924 when his family moved to Philadelphia, his parents separated and his father moved away.

His mother cleaned houses to make ends meet, but she could not support her family. She decided to move to New York City to find work. For three years, Jake and his brother and sister lived in foster homes in Philadelphia until his mother was able to bring them to New York. When his family moved to Harlem, an African-American neighborhood in New York City, an art teacher in an after-school program helped Jake realize his dream of becoming an artist.

From early on, Jake liked to draw and while growing up he explored his neighborhood for subjects. He was fascinated by the shapes of ants and grasshoppers and the way they moved. He caught them and drew them on scraps of paper.

◀ **Jacob Lawrence in his studio in Seattle, Washington.**

> **"Our homes were very decorative, full of a lot of pattern, like inexpensive throw rugs, all around the house... I used to do bright patterns after these rugs; I got ideas from them..."**

Although Jake was shy and did not make friends easily, New York City was a new and exciting place for him. He loved to walk around the neighborhood and watch all the activity in the streets. To keep him busy and out of trouble, his mother enrolled him in an after-school arts and crafts program. And because Jake was not athletic, instead of playing sports, he spent every afternoon in his art classes learning to draw and paint.

There was no formal teaching or instruction in the program, but Jake's teacher recognized he had talent and encouraged him to learn and experiment as much as he could. In his classes, Jake painted with poster paints which are also called gouache or tempera paints. Jake continued to use these fast-drying paints his whole life. He liked all the bright solid colors and he painted with them in simple patterns like the ones he saw on the throw rugs and the fabrics in his home. "It must have had some influence, all this color and everything. Because we were so poor, people used color as a means of brightening their life."

A painting of an interior is a painting of the inside of a house or room. In this painting Lawrence has a powerful and imaginative sense of color and pattern—the bed and the dresser seem to float in the air, stripes have a life of their own, an abstract patterned rug climbs up the wall, dishes and cups dance on the table. The activity of these things contrasts with the silhouette of the woman, his mother, walking into the apartment hunched over after a hard day of work.

● Go to page 4 in your Activity Book to paint an interior in your own home.

J ake also created his own system of painting. He painted only one color at a time, adding one color after another, until his painting was finished.

Lawrence painted everything he saw. He liked the way fire escapes looked in front of the apartment buildings in Harlem and they became a favorite subject. In every doorway and alley and window, there was always a different scene or story unfolding. In 1942, Jake made a group of paintings called the Harlem Series. These paintings describe his memories of growing up in New York City.

"I paint the things I know about and the things I have experienced."

Jacob Lawrence painted what he remembered growing up in Harlem neighborhood. The colors and composition he used shows the liveliness of billboards and signs, life on the streets and life through the windows of the apartment buildings. Not all cities show as much activity and in this painting Lawrence shows us the many different and unfolding stories he saw in Harlem.

Notice the patterned fire escapes that Lawrence liked so much.

● Go to page 4 in your Activity Book to paint the city or town you live in.

Paint a scene.

Harlem was the home to many artists, writers, musicians, entertainers and intellectuals. It was a lively and artistic community and the period when Jake lived there was known as the Harlem Renaissance. When Jake's art teacher left the after-school program to teach at the Harlem Art Workshop, Jake followed him to get more serious instruction. At night and in any spare time he had, he could be found painting in the Workshop studios. He met many artists at the Workshop and he had many teachers and mentors.

In 1934, Jake dropped out of high school when he was sixteen years old and worked to help his mother support the family. During the day, he took odd jobs at a laundry and a print shop. He also had a paper route delivering newspapers. His mother was unhappy that Jake quit school and wanted to be a painter. She did not know what he would amount to and wondered how he would be able to make a living. To please her, Jake worked in construction, building a dam in upstate New York.

"Whenever I relive my early years in the Harlem community, the barber shop... is one of the scenes that I still see and remember."

A barbershop in the 1940s was not only a place for a haircut and a shave, it was a place for men to socialize. It was a vivid childhood memory for Lawrence. In this painting in which he paints very few details, Lawrence made a strong abstract pattern of the barbers at work and the men wearing smocks in the barber chairs.

And just as in his childhood, he always painted in quick drying tempera or gouache paints, also known as poster paints.

● Go to page 5 in your Activity Book to paint your own memory.

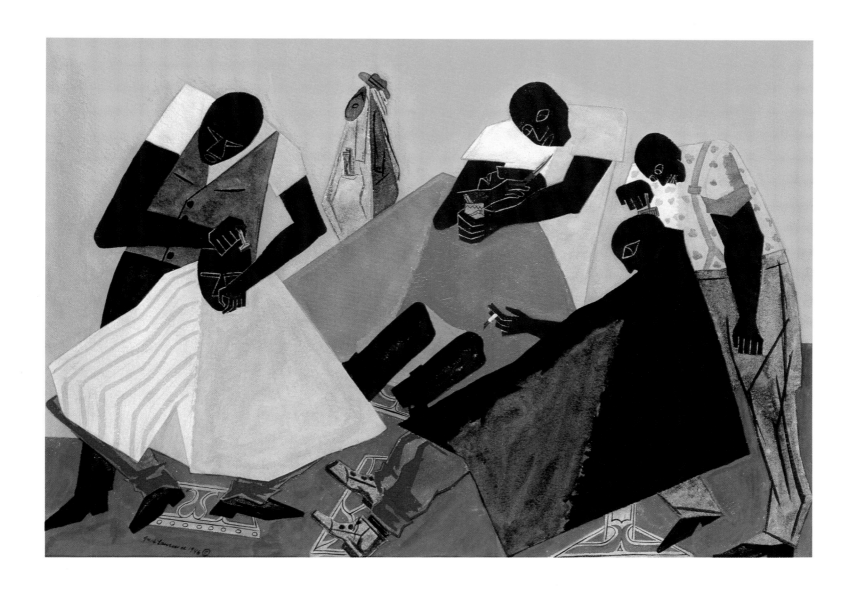

Barber Shop 1946
Gouache on paper, 21 ⅛ x 29 ⅜"
Toledo Museum of Art, Ohio, gift of Edward Drummond Libbey

11

A year later, Jake returned to Harlem and received a scholarship to an art school in downtown New York. At night he continued to paint. One evening at the YMCA, he heard a man called Professor Seyfert speaking in a crowded room. Jake stopped to listen and was immediately engaged by him. It turned out that the man was not really a professor, but was actually a carpenter who gave lectures in African-American history to anyone who would listen. He also encouraged black artists to paint pictures that could show black people their history and inspire them.

Jake was so impressed by the professor's lecture that he decided to paint a series of paintings about the history of African-Americans.

"I've always been interested in history, but they never taught Negro history in public schools."

This painting is one of sixty panels Lawrence painted to tell the story of the migration of African Americans from the south to the northern cities during World War I. Jake's own father and mother had moved from the south with their families to escape poverty and racism and to find better jobs and opportunities in the northern cities. When he was growing up, he would always hear of "a family coming up" and they would gather food, clothing and coal for the arriving family. In his later works, Lawrence painted fewer and fewer details and combined strong colored patterns and silhouettes to tell his story.

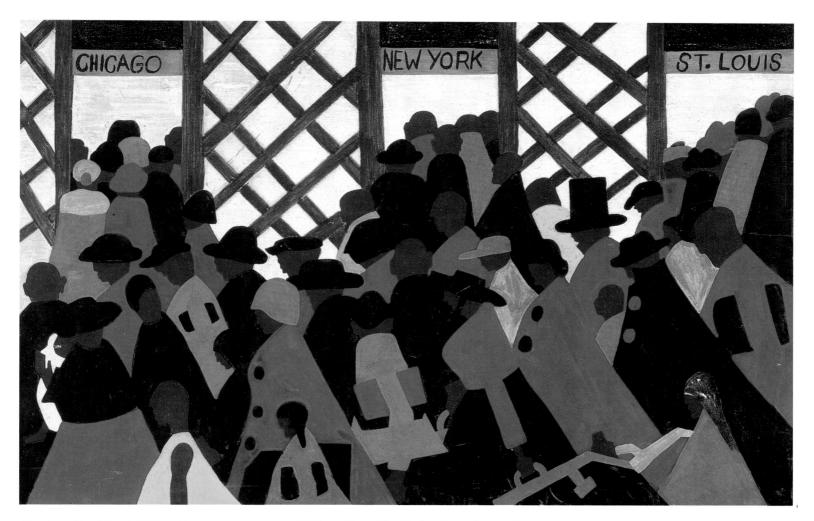

During the World War there was a great Migration North by Southern Negroes.

The Migration of the Negro, Panel 1 1940–41
Casein tempera on hard board, 12 x 18"
The Phillips Collection, Washington, D.C.

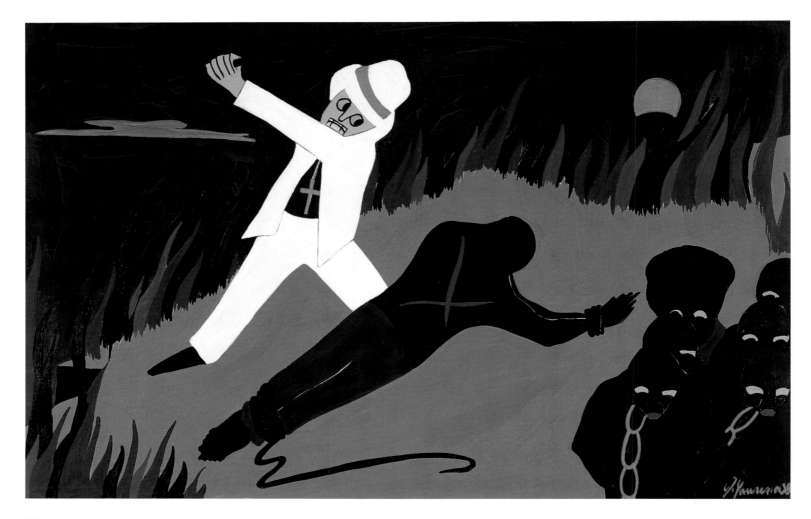

The cruelty of the planters towards the slaves drove the slaves to revolt, 1776. Those revolts, which kept cropping up from time to time, finally came to a head in the rebellion.

The Life of Toussaint L'Ouverture, No. 10, 17, 36. 1938
Tempera on paper, 11½ x 19, 19 x 11½, 11½ x 19"
The Amistad Research Center, Tulane University, New Orleans
Aaron Douglas Collection

Toussaint captured Marmelade, held by Vernet, a mulatto, 1795.

During the truce Toussaint is deceived and arrested by LeClerc. LeClerc thought that with Toussaint out of the way, the Blacks would surrender.

Jake's first series was about the General Toussaint L'Ouverture who was a slave in Haiti and led his country to freedom. Jake spent many hours at the public library reading and learning everything he could about the General. These are three paintings of forty-one panels Lawrence painted to tell his story. In this series of paintings, Jake carefully chooses scenes from the tragic slave trade and Toussaint L'Ouverture's heroic fight for freedom. Think about how hard it is to tell a story in one painting. Jake discovered that a series of paintings was the best way for him to paint historical stories.

● Go to page 5 in your Activity Book to paint your own story.

Painting a series.

The year Jake turned twenty-one he had his first one-man exhibition. He was also invited to join a government art project called the Works Project Administration (WPA) that paid artists to create two paintings every six weeks and provided art materials and a studio to work in.

He was friendly with many artists in the program especially a young woman named Gwendolyn Knight, who hired Jake to pose as a model for her paintings. They went to museums and galleries together and had many discussions about art. They often walked sixty blocks to visit the Metropolitan Museum of Art. Jake especially liked the Mexican paintings and murals there, "the pure, bold color, the big forms…the content-dealing with people."

"I want to do a series of paintings that will tell the whole story."

During the project, Jake painted the stories of African-American heroes who fought against slavery in the United States. One was about Frederick Douglass, a slave in Maryland who later became a statesman. Another was about Harriet Tubman, a woman who helped slaves escape to freedom by leading them at night through an underground railroad. He also painted the stories of John Brown and George Washington Bush.

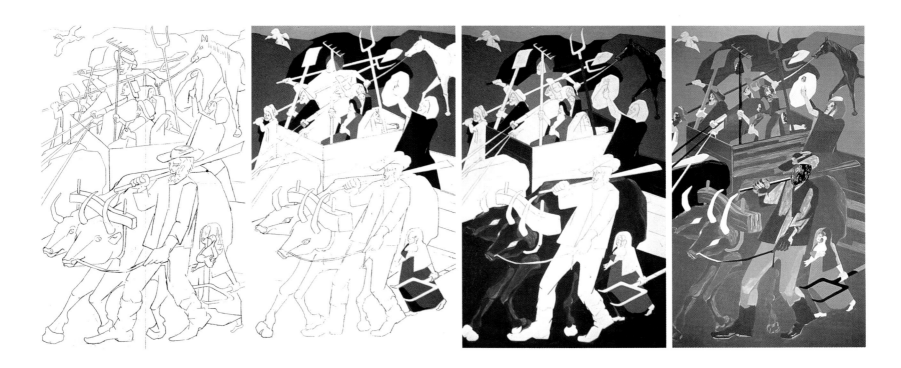

George Washington Bush. No. 2.
In the Iowa Territory, they rendez-voused with a wagon train headed for the Oregon Trail, 1973 (in progress)
Casein tempera and gouache on paperboard 31½ x 19½"
Washington State Capital Museum, Olympia

George Washington Bush was an African-American who helped to establish the state of Washington. These illustrations demonstrate Jake's technique in making one of the panels in this series. He first sketched each scene on a piece of paper. Then he took one color at a time and painted it in all the panels. One by one Lawrence filled in all the colors that would make the final paintings. He created this unusual technique because he wanted the colors to be exactly the same in each panel. He thought color would help unify the story.

● Go to page 6 in your Activity Book to paint a series.

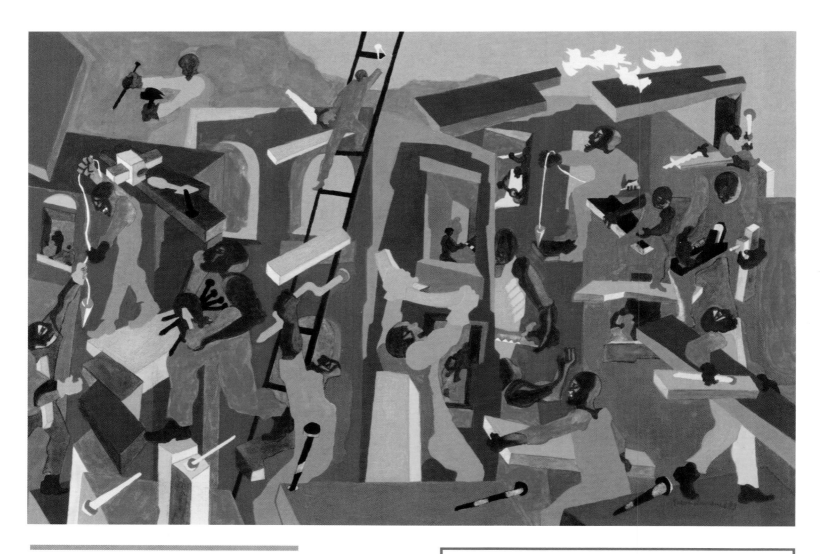

Builders in the City 1993
Gouache on paper, 19 x 28½"
Courtesy of SBC Communications, Inc.

Lawrence painted the Builders series soon after he moved to Seattle, Washington to teach art. At the time, there was new construction everywhere in the city and he loved to watch it. He became fascinated by the hand tools the workers used and began collecting tools himself.

fter the government art project ended, Jake received grants to paint a series of paintings about the great migration of African-Americans from the south to the north during World War I.

By 1940, Jacob Lawrence was still not very well known outside of Harlem, but that changed when the Migration Series appeared in a national magazine and all the paintings were sold to two major museums in New York and Washington, D.C. Jake became an overnight success even though he did not even go to the opening of his gallery show. He and Gwen married and they were on their honeymoon in New Orleans. The Migration Series would travel to museums throughout the United States.

> "I don't think about this series in terms of history...
> It was a portrait of myself, a portrait of my family,
> a portrait of my peers..."

Shortly after the newlyweds returned to New York, Jake was drafted into the U.S. Coast Guard. An officer who recognized Jake's talent appointed him the official U.S. Coast Guard painter. He painted many works during his service. He recorded the daily routine and activities aboard a ship at sea and at port. He believed that, "a man may never see combat, but he can be a very important person" and he portrayed the sailors who cooked and cleaned and performed the everyday jobs in the Coast Guard. His war experience inspired him to paint the War Series after he was discharged.

Jake returned to New York and continued to paint. His work was shown in museums and galleries around the country. He was a recognized artist and was invited to teach and lecture at many art schools and universities. At fifty-four years old, Jake and Gwen moved to Seattle where he became a professor at the University of Washington. He retired from teaching when he was sixty-nine, but he continued to make art.

Jacob Lawrence painted every day of his life. He illustrated books, he painted murals in public buildings, and he continued to make series of paintings from his life experiences. Of his work, his favorite paintings were from the Builders series, a group of paintings about construction workers. He said, "some of my paintings show man's struggle, but building shows the beauty of people working together." Jacob Lawrence died at age eight-two on June 9, 2000 of lung cancer.

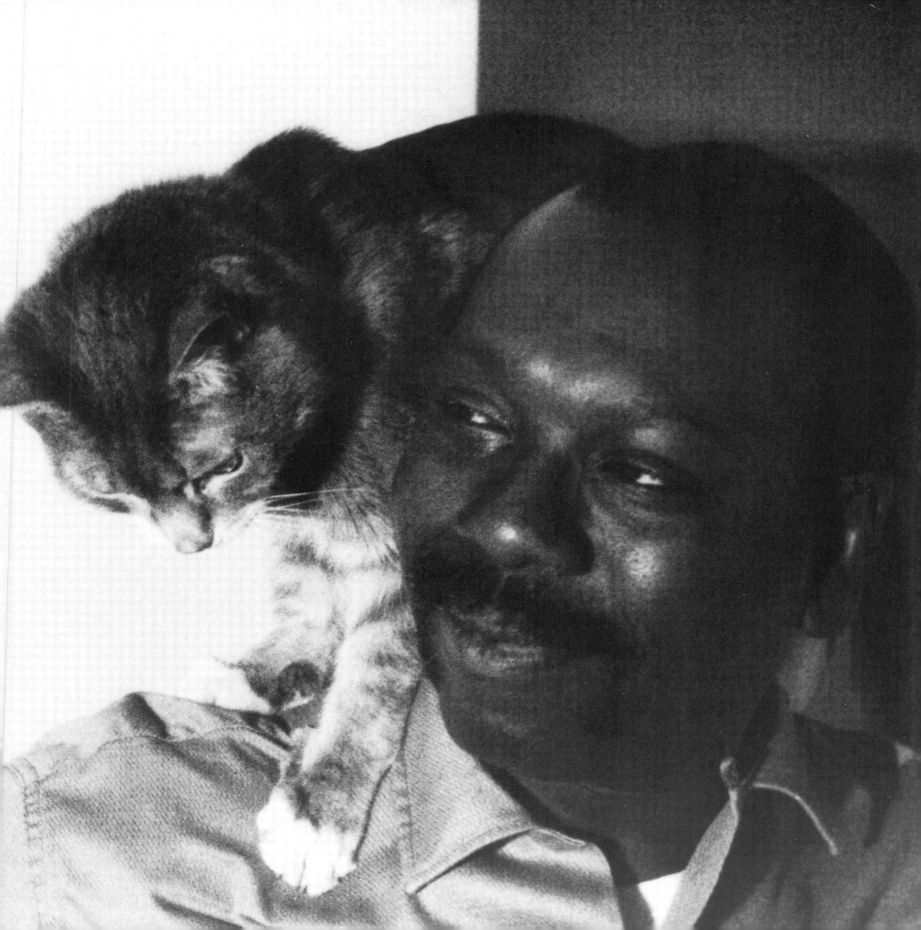

BIOGRAPHY

1917 September 7, Jacob Armstead Lawrence born in Atlantic City, New Jersey.

1924 Moves to Easton and Philadelphia, Pennsylvania. Father moves out.

1927 Mother moves to New York City to find better job opportunities.

Placed in foster homes with brother and sister.

1930 Moves to New York City and attends Frederick Junior High School, P.S. 139. Takes arts and craft classes at Utopia House.

1932 Attends High School of Commerce. Studies art after school at the College Art Association, Harlem Art Workshop.

1934 Drops out of high school. Takes odd jobs.

Studies art at night at WPA art classes, Harlem Art Workshop.

1936 Receives scholarship to the American Artists School. Begins to paint Toussaint L'Ouverture series, forty-one paintings.

1938 Hired by the WPA Federal Art Project easel section. Begins to paint Frederick Douglass and Harriet Tubman series.

First one-man show at the Harlem YMCA.

1939 First group museum show at the Baltimore Museum.

1940 Paints Migration series, sixty paintings. Sold to the Phillips Collection, Washington, D.C. and the Museum of Modern Art, New York.

1941 Marries the painter Gwendolyn Knight. Honeymoons in New Orleans.

1942 Returns to Harlem. Begins to paint Harlem series.

1943 Drafted into the U.S. Coast Guard. Promoted to Petty Officer 3rd Class, Public Relations Branch to be official painter of the Coast Guard.

One-man show at the Museum of Modern Art, New York.

1945 Discharged from the Coast Guard. Paints War series.

1946 Teaches at many art schools and universities over twenty years.

1960 First retrospective at the Brooklyn Museum, New York.

1968 Paints Builders series.

1971–86 Full Professor at the University of Washington, Seattle.

1974 Major retrospective at the Whitney Museum of American Art, New York.

1982 Retrospective at the Clark Humanities Museum, Scripps College, Claremont, California.

2000 June 9, Jacob Lawrence dies of lung cancer.

BOOKS ABOUT JACOB LAWRENCE

Story Painter: The Life of Jacob Lawrence by John Duggleby. Chronicle Books: San Francisco, California, 1998.

Jacob Lawrence: Thirty years of Prints by Peter Nesbett. University of Washington Press: Seattle, Washington, 1994.

Jacob Lawrence: The Migration Series. Exhibition catalogue: September 23, 1993 - January 9, 1994. The Phillips Collection, Washington, D.C. Foreword by Charles S. Moffett, edited by Elizabeth Hutton Turner, introductory essay by Henry Louis Gates, Jr., essays by Lonnie G. Bunch III and Spencer R. Crew, Patricia Hills, Elizabeth Steele and Susana M. Halpine, Jeffrey C. Stewart, Diane Tepfer, Deborah Willis.

Jacob Lawrence, American Painter. Retrospective catalogue: 1986
Seattle Art Museum with the University of Washington Press, Seattle Washington. Foreword by Bruce Guenther, essay by Patricia Hills, by Ellen Harkins Wheat.

Jacob Lawrence. Retrospective catalogue: May 16– July 7, 1974. Whitney Museum of American Art, New York by Milton W. Brown.

MUSEUMS WHERE YOU CAN SEE HIS WORK

Alabama, Birmingham	Birmingham Museum of Art
Georgia, Atlanta	High Museum of Art
Indiana, Evansville	Evansville Museum of Arts and Science
Kansas, Wichita	Wichita Art Museum
Louisiana, New Orleans	New Orleans Museum of Art
Maryland, Baltimore	The Baltimore Museum of Art
Massachusetts, Boston	Museum of Fine Arts
Michigan, Detroit	Detroit Institute of Arts
Minnesota, Minneapolis	Walker Art Center
Missouri, St. Louis	St. Louis Art Museum
New York, Brooklyn	Brooklyn Museum of Art
New York, Buffalo	Albright-Knox Art Gallery
New York, New York	The Metropolitan Museum of Art
	The Museum of Modern Art
	Whitney Museum of American Art
North Carolina, Raleigh	North Carolina Museum of Art
Oregon, Portland	Portland Art Museum
Pennsylvania, Philadelphia	Philadelphia Museum of Art
Tennessee, Chattanooga	Hunter Museum of American Art
Texas, Dallas	Dallas Museum of Art
Virginia, Richmond	Virginia Museum of Fine Arts
Washington, D.C.	The Phillips Collection
Washington, Olympia	State Capitol Museum
Wisconsin, Milwaukee	Milwaukee Art Museum